Collaboration in Art Education

Al Hurwitz
Department of Art Education
Maryland Institute, College of Art

1993

National Art Education Association
1916 Association Drive
Reston, Virginia 22091-1590

D1293840

About NAEA . . .

Founded in 1947, the National Art Education Association is the largest professional art education association in the world. Membership includes elementary and secondary teachers, artists, administrators, museum educators, arts council staff, and university professors from throughout the United States and 66 foreign countries. NAEA's mission is to advance art education through professional development, service, advancement of knowledge, and leadership.

About the Noted Scholar Series . . .

Collaboration in Art Education by Al Hurwitz is the second book in NAEA's noted scholar series. The series was designed to recognize and honor art education scholars. The other title in the noted scholar series is *The World of Art Education* by Vincent Lanier.

About the Author . . .

Al Hurwitz holds a B.S. and M.A. from George Peabody College, an M.F.A. from the Yale School of Drama, and an ED.D. from Pennsylvania State University. He has taught art in Tientsin, China and Dade County, Florida (K-12) where he also served as art supervisor and television instructor. In Massachusetts, he held a dual appointment—Director of Visual and Related Arts for the Newton Public Schools and Associate Professor for the Harvard Graduate School of Education. He is a former NAEA Vice-President and past president of INSEA and USSEA. A recipient of numerous awards, he has received the Higher Education, Distinguished Fellow, and Art Educator of the Year awards of the NAEA and the Edwin Ziegfeld and Sir Herbert Read Awards. He has been named as a Distinguished Alumnus by Pennsylvania State University and the Maryland Institute, College of Art and has written or co-authored a dozen books and numerous articles for all art education publications. He is a trustee of the NAEA and currently is Emeritus Chair, Department of Art Education, Maryland Institute, College of Art, is married and has three children.

© 1993 The National Art Education Association, 1916 Association Drive, Reston, VA 22091-1590.

ISBN 0-937652-67-9

Contents

Photographs

Dedication

This book is dedicated to Maesa, Maria, Nathan, Jack, Lewis, and Isaac.

Do you remember when I took you to the top of the tallest building in our city and I said,

"When I was a boy the land you see below us was clear. The only people around were Apaches and Iroquois and come spring, the Cherokee and Huron would hold their annual pow wows to swap everything from tall tales to Indian ponies. They would eat, dance and sing and their celebrations could go on for days.

"But Papa," you said, "How could this be? The Cherokee lived in the Carolinas and what Iroquois are you talking about, the Mohawks, the Cayugas or the Senecas, all of who held the land in central New York? The Apaches, as everyone knows, lived in the Southwest and ..."

"I know all that," I said. "Well, now you know my secret."

I recall when you and I stood on a rise that lay between the flatland of this valley and the mountains that rise just behind us and I said "When I was your age this land was far from peaceful. I was impatient and eager to join the real world of adults and I fell in with the wrong crowd. I knew Quantrel and for a time I rode with Cole Younger. To make an extra dollar, I even rode shot-gun on the stage between Abilene and Yuma. Those were hard times for struggling artists, let me tell you."

"But Grand-pa," you said, "How could this be? Cole Younger and his like died long before you were born and no stage coach was ever scheduled between the Arizona and Texas territories, that I know of..."

"So," I replied, "you too know my secret. Well, if it's secrets you want, how about this? Did you know I knew and loved you even before you were born?"

"That's no secret," you replied, "and if it were, it would surely be safe with me."

Acknowledgements

I would like to thank a remarkable group of artists and art teachers, most of whom, unfortunately, are strangers to each other.

The following teachers from Newton, Massachusetts: Bob Andrews, Arlene Bandes, Sam Buselle, Judy Gruenbaum, Mimi Jenkinson, Ray Lavin, Siever Leslie, John O'Neill, Willard Robinson, Lloyd Schultz; and Yvonne Anderson, Rhode Island School of Design; Lowry Burgess, Dean, School of Art, Carnegie Mellon University; Dr. Karen Carroll, Chair, Department of Art Education, Maryland Institute College of Art; Irene and Jim Cobb, Sydney, Australia; Isaka Gaon, Curator, Israel Museum; Tracy Hesketh; Shirley Hodges, Tabb High School, Tabb, Virginia; Prof. Hachiro Iizuka, Director, Tokyo School of Art; Linda Jorgenson, Elementary Art Teacher, Blair, Nebraska; Dr. Leaven Leatherbury, Editor, *Arts and Activities*; Dr. Peter London, Department of Art Education, Southeast Massachusetts University; Dr. Paul Ritter, Perth, Australia; Richard Loveless, Director, Institute for the Studies in the Arts, Phoenix, Arizona; Dr. Stanley Madeja, Dean, Center for Visual and Performing Arts, Northern Illinois University; Akeo Murakami, Elementary Art Teacher, Japan; Lilli Ann and Marvin Rosenberg, Artists in Residence, Newton, MA; Irma Sangiamo, librarian, Maryland Institute College of Art; Rebecca Sharpe, Bullitt Central High School, Shepardsville, Kentucky; Pedro Silva, Artist; Gerd Stern, Media Artist; Dr. Amy Brook Snider, Chair, Department of Art Education, Pratt Institute, Brooklyn, N.Y.; Dr. Ray Thorburn, Auckland, New Zealand; Dr. Antoinette Ungaretti, Johns Hopkins University; Caterina Vietorisz, Art Teacher, Nashville, Tennessee; Annette Wagisbach Watson, Director of Houston Independent School for the Arts; Jane Winnie, Art Teacher, Aukland, New Zealand; Public Relations Department, Maryland Institute, College of Art for the use of a photograph.

B. T. Batsford, Ltd. for permission to use their illustration.

Middleton Evans for permission to use his photograph from "Living Reproductions" program of Roland Park Country School, Baltimore

I am also indebted to Alan Kaprow, Paul Brach, Peter Kahn, and Newton Harrison for many discussions held at our Advanced Placement Program meetings. They were perhaps the most unique group of artists ever to help shape the thinking of a public school art administrator.

To Helen Hurwitz and Shay Taylor, who made this book possible through their deciphering and typing skills, a special heartfelt note of appreciation.

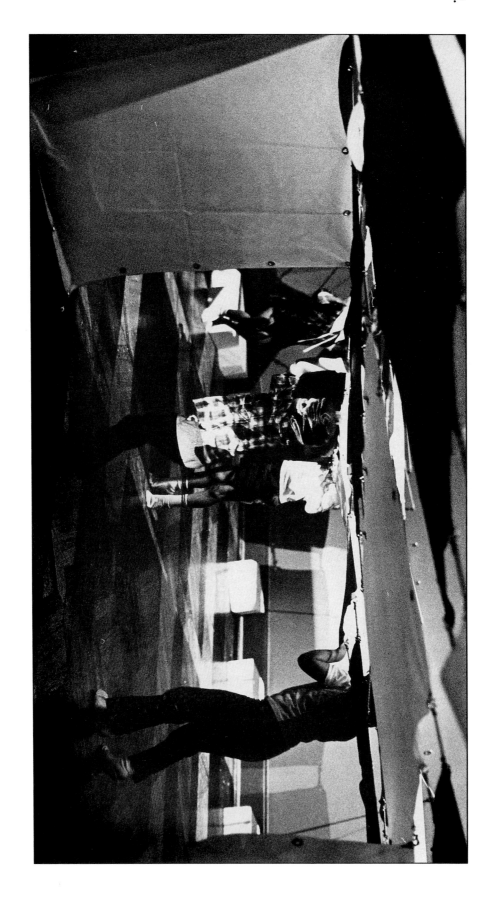

"Space Place," one example of the first settings for large scale participatory activity for children designed by Stanley Madeja.

INTRODUCTION

American art educators rarely if ever base classroom practice upon anecdotal accounts of personal statements. One exception is Natalie Cole's The Arts in the Classroom.[1] Great Britain, despite a negligible audience for art educators, by U.S. standards, does honor such writers. Three that come to mind are the books of Seonid Robertson[2], Marion Richardson[3] and Sybil Marshall[4]. Since Thomas A. Hatfield, Executive Director of the NAEA, has generously assured me complete freedom, I will take him at his word and allow myself the luxury of placing my ideas in a personal as well as a professional context. As a former teacher and supervisor, I have been fortunate in having lived and worked through some important stages of our history. I have tried to present these from the point of view of a practitioner. In defending personalized treatments of the past, Vincent Lanier wrote: "Occasional reminiscences that highlight a point in our history may help to lend an air of authenticity and humanity to what might otherwise be turgidly didactic."[5] I heartily concur.

I have also tried to avoid stressing the proscriptive or how-to-do-it approach and, instead, will attempt to describe and illustrate participatory approaches to creative activity on the assumption that any teacher with a modicum of inventiveness can solve the workaday problems that await the transference of new ideas to the classroom.

The illustrations shown have been selected to convey the range of collaborative activity as it exists both here and abroad and should be seen as a series of opposite attractions separated by an indeterminate number of variations. As an example, chalk-ins are usually random events but can also be carried out within a set of rules and follow a plan. Whatever their context, chalk-ins are by their very nature transitory while ceramic murals are as permanent as one can get. Students can initiate projects or they can assist artists-in-residence. Although animation and intermedia production are complex and time consuming, a film can be created in one class period when one works directly on raw film. A class can work as a group without ever venturing beyond the walls of the art room or it can embrace an entire community—projects can serve social needs or be carried out simply for the pleasure of the participants. The materials of group art can be as ancient as charcoal or as contemporary as a hologram.

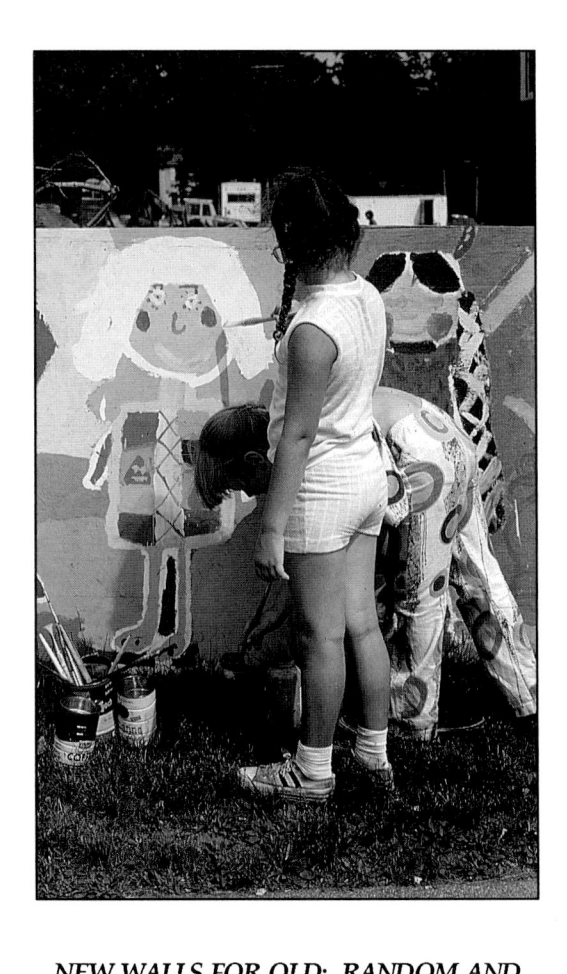

HOLOGRAM MURAL (above)—Inspired by the work of artist Chuck Henry, fifteen students at Tabb High School (Virginia) created a number of mural panels based upon the use of holograms. Sherry Hodges, the art teacher, has used group art as a major component of her program and has written her M.A. thesis on her experience (see Bibliography). The students are seated before a segment of a "blow-up" of a segment of painting.

NEW WALLS FOR OLD: RANDOM AND UNPLANNED (above)—There is something universally compelling about the idea of covering a wall with images or simply enjoy the art of spreading paint. (Remember Tom Sawyer's picket fence?) From the caves of Altemira to the interiors of temples and churches; from Pompeiian living rooms to the exteriors of abandoned tenements, artists have been unable to resist flat surfaces that allow them to work on a scale that is compatible with the dimensions of their bodies. Nothing changes the character of a space so conclusively as the redefinition of a wall.

THE NATURE OF COLLABORATIVE
GROUP ACTIVITY

Group art can be likened to an amoeba; although outward forms are in a constant state of flux, the essence remains constant. One difficulty in categorizing group activities lies in the ways in which styles borrow from each other. There is really only one condition which must be shared; namely, that two or more participants be brought together to create an object or event which in some way, exists beyond the effort of a single person. Beyond this, group activity can assume many forms. The goal for one work may be reached in one class period. Should the focus of a project be upon experiencing the process of change as it can occur through a succession of activities, group art can take much longer. Students may employ traditional materials such as paint or non art media such as straw; they can be guided by rules or provide choices that lie within constraints. Why then should one even attempt to bring some order into a category of art activity so resistant to classification? Since all of us need handles of understanding to grasp in new situations, a home base to establish some general distinctions can be helpful.

Several terms are subsumed under the general heading of "collaboration," and while meanings are shared in some cases, variations do exist. Although a *collaborator* is one who works with a partner as an associate in a project shared by both parties, collaboration can involve any number of parties, as in the case of the Architects' Collaborative in Cambridge, Massachusetts. Baltimore's Visual Arts Collaborative which brings poets and artists together, or the Center for Advanced Visual Studies at the Massachusetts Institute of Technology which encourages liaisons among artists and scientists. When everyone is involved in the success of a venture, the terms *"participatory activity"* and *"process art"* are often used interchangeably. Painting a mural, creating a table top model for a new city, or making a film are examples of groups or teams who work collaboratively in a process which differs from that engaged in by those who work alone.

In writing of her experience as coordinator for a project for the Virginia Museum of Fine Arts Resource Center for Children, Amy Brook Snider lists the following "Principles of Collaboration" as necessary conditions for a group working with a shared goal in mind.

1. It is essential to be open to a variety of experiences (oftentimes outside one's own discipline) and receptive to the possibility of encounters with "kindred spirits" in a variety of guises.

2. Allowing one's work to be a medium for all kinds of professional interactions is a form of brainstorming, producing other possibilities.

3. Questions and open-ended structures for thinking about problems form the modus operandi of all phases of the work.

4. A respect for the other's point of view and a willingness to support it against opposition is critical to the process.

5. The environment must be comfortable and conducive to an atmosphere of trust and reflection; ideally, separate from the participants' traditional workplaces.

6. Meetings should have a leader.

7. More connections are made possible through shared experiences.

8. A predisposition toward collaboration is the willingness to allow others to work "themselves" upon you.

Group activities can be closed off at a certain stage or provide a basis for developing other ideas. After a lesson in modeling the human figure in clay, as an example, most students will assume the lesson is over, when in fact, they may have done no more than complete the first stage. The completed figures could then be placed in a setting of some sort, such as a rambling table sculpture based upon biomorphic forms, or a large piece of driftwood. Using a theme from art history, such as Rodin's *Gates of Hell* or Gustav Dore's illustrations for Dante's *Inferno*, the same figures could turn into a mass of humanity, writhing in agony. In such a sequence, the first stage (modeling) was used as a way of entering into the spirit of an art work.

Or take the case of a senior high teacher[6] who inherited a bare space for an art room and used the simplest of materials (cardboard) to create utilitarian structures which could lead to a purely aesthetic event. (Figures 1, 2, and 3)

Figure 1

In the first phase, students using cut-all saws devised ways of converting sheets of triple ply cardboard into such basic classroom furniture as tables, chairs, and storage units. This involved planning, cutting and slotting, and interpenetrating the forms. Those

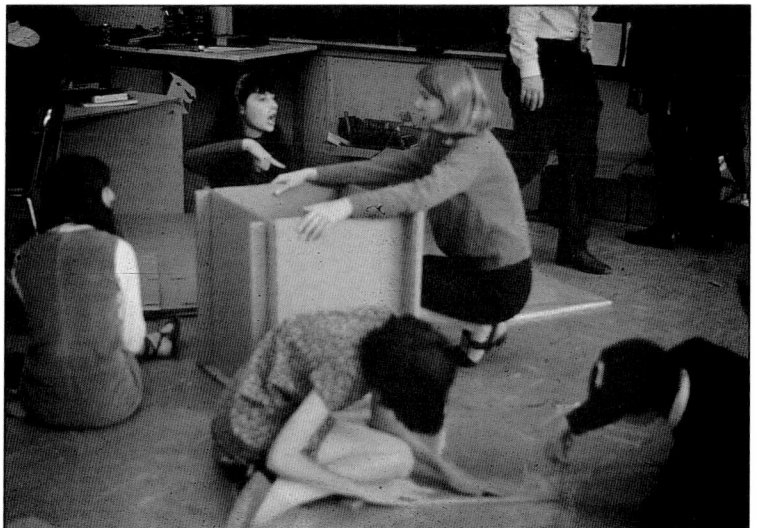

Figure 2

who assumed the project was over and that "serious" work in art could now begin could not have been more mistaken. When the last piece was finished, the teacher asked the class to disassemble everything and move all components to the playground. Here the class was divided into three groups and asked to reassemble the sections into a unified piece of sculpture. Since each group had an equal number of components, the class could appreciate the open-ended character of solutions to visual problems. They also learned that the materials of the artist can provide functional as well as purely aesthetic solutions. Throughout this second phase, the teacher was acutely aware of the problems encountered during all decision making processes.

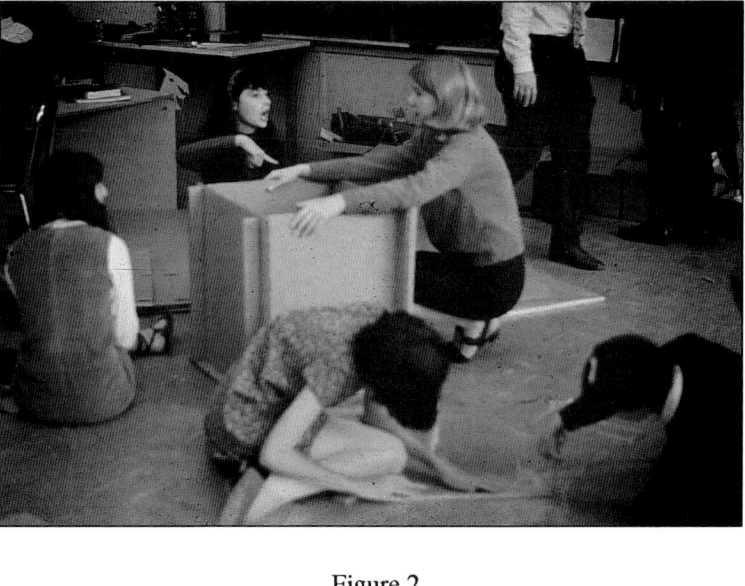

Figure 3

Nuances of meaning become clearer as one studies specific examples. Chalk-ins, a looser form of group art, are less collaborative and because of their random nature, can be carried out without the kind of discussion, brainstorming, and planning that is needed to design a playground for a new nursery, where, participants are required to listen, evaluate, and search for consensus — none of which may be necessary for the informal chalk-in. There can be no collaboration without interaction on some levels.

The words *collaborative, group,* and *participatory* are overlapping concepts and, as in the case of solo forms of expression, cover a boundless range of choice in style, materials, techniques, and themes. These can take the form of events in time (as in a procession) or a single work such as an installation. Group art can commemorate an occasion, serve as entertainment, provide a forum for political action or dramatize an idea. *All group work operates through individuals who use visual materials to create a work or event which could not be attained through the efforts of any single individual.*

The exact result of group work may or may not be predetermined. Martin Buber once wrote, "Every journey has a secret destination of which the traveler may not be aware." Buber's comment poses the question, What if the goal of the group is something which awaits discovery? In such cases, the goal resides in the process — that mysterious journey of which Buber speaks. When the importance of creation supersedes that of the final product, it is *process* art. In story theatre, when a teacher decides to dispense with a prepared script and base dramatic activity upon improvisations of dialogue and action, it may not be possible or even desirable to foresee the final result since the excitement of "making it up" as you go along may have as much value to the participants as what the audience sees on opening night. When one works from a prepared script, the role of the leader, or director, becomes a dominating factor; in working within a story-theatre format, the role of the director changes to one who generates the flow of ideas, hunches, extemporaneous action among the members of the group. When this occurs, the audience receives the story as shaped by the participants rather than be a playwright.

Udu Kulturman's remarks concerning the intermedia movement in Europe are an accurate description of what can happen in a group based activity. "…different threads come together…and it is their mutual influence and enrichment crossing all boundaries that is the common bond between them."[7]

Teachers should value group activity if only for its socializing value. When students are called upon to defend a suggestion and to pay attention to the ideas of a classmate, they learn from each other in ways which they, rather than the teacher, create. When they are willing to relinquish their own ideas to achieve consensus, students experience the essence of the democratic process.

This can be especially important for the teacher who works with mixed populations. Isaka Goan, a curator of the Israel Museum in Israel stresses social needs of group art in describing the children's program at his museum as follows:

"Group art plays a major role in the education program of the museum for a very good reason: this kind of art provides the only social occasion wherein so many different kinds of children share some sort of joint enterprise. Israel is more socially stratified than many of us would like to admit. The children of Russian refugees, of Yemenites, Arabs, Ethiopians, and of older established families, keep pretty much to themselves until military service. The museum gets them working together in the afternoons and on weekends, either as participants or leaders. Thus, art helps to serve the needs of society in a very practical sense. Rugged individualism may not be as important as the ability of individuals to meet an emergency together."

Since it is the teacher's responsibility to make certain that all students are represented, group art is less competitive than most art programs. Contests, as an example, by their very nature create winners and when there are winners, inevitably there are losers. When students rethink the nature of failure and success, they feel freer to take risks and to envision possibilities which lie beyond immediate solutions. Failure need not be equated with losing and can instead be regarded as a way of learning—as in the case of the "Almost Magnificent Flying Machine."

Through an arrangement with Boston's Institute of Contemporary Art, a class of ninth graders was able to assist sculptor Hans Von Ringleheimer in preparing the biggest handcrafted flying machine ever constructed. On Friday, the components (largely seamed mylar) were constructed in the gymnasium of a junior high school. Saturday was spent assembling the parts on the open plaza before Boston's new City Hall. By evening the "machine" was assembled and ready to launch. Although the machine barely got it off the ground, the participants did manage to build the most formidable kite the world has ever seen. It hovered uncertainly over the plaza, then collapsed with a gentle thud. It was an experience the kids will not quickly forget and no one felt it was in any sense a failure. The project involved not only ninth graders, but parents and a number of younger artists who were interested in the progress of the event. All in all, it was a group of strange but compatible bed fellows.

In some cases, it may not be possible to know when a collaborative project is completed. When a class paints a mural directly on a cafeteria wall, everyone can become involved in some phase of preplanning in order to minimize the many kinds of failures that can occur (spilled paint, accidents on scaffolding, controversial imagery, etc.). Such a mural is a collaborative activity

carried out with a minimum of risk. If, however, everyone in the school is invited to participate by spontaneously making their own contributions, then the project involves more factors of the unknown, therefore greater risk. It's the difference between "I want to know what's going to happen" and "anything can happen." A case in point is "Gas Station," a middle school project that could only have existed in a special program. The goal here was to immerse ourselves in a commonplace subject and in so doing, discover the wealth of associations which go unnoticed in the most unlikely places. Over the course of a week, twelve students gathered data through drawings, slides of drawings, taping the sounds of a gas station, video taping interviews with customers, identifying and photographing examples of elements and principles of art. At the end of the week, they faced the problem of creating some sort of integration of all of the components into a presentation for friends and parents. Since there were no guidelines available for such a presentation, learning began at ground zero. The students were put into a position of solving a problem without recourse to any established form of practice, a species of learning that is new to most of us.

There are other differences in behavior that separate private and public art. Children working by themselves do best when they work from the inner realms of memories, dreams, and experiences as sources of art making. When we draw upon our private, interior selves, we work from observation and memory in ways which are also familiar to actors. In describing one painter's ability to use memories of his personal history, psychologist Oliver Sacks noted:

"Franco can hear the church bells ("like I was there"); he can feel the churchyard wall; and, above all, he can smell what he sees — the ivy on the church wall, the mingled smells of incense, moist and damp, and admixed with these, the faint smell of the nut and olive groves that grew around the Pontito of his youth. Sight, sound, touch, smell at such times are almost inseparable for Franco, and what comes to him is like the complex and coenesthetic experience of early childhood..."[8]

This is the kind of intense self examination which so often guides artists, writers, and others who work alone. Groups, on the other hand, do better in collaborative design projects such as a playground, a house or city, or producing a play. Artists may choose or elect not to look within themselves, but collaborators have no choice but to reach out to others. Because of this, collaborative action holds the promise of more effective communication between individuals. It supports the notion that a group of people can create and share in the same authenticity of artistic experience associated with individual creation. Composer John Cage sees it as follows:

8

"Art, instead of being an object made by one person, is a process set in motion by a group of people. Art's Socialized. It isn't someone saying something, but people doing things, giving everyone (including those involved) the opportunity to have experiences they would not otherwise have had."[9]

Group art depends heavily upon the chemistry that is created by the interaction that occurs when participants must make the decisions which lead to the creation of the work. Collaborative art is also an act of faith, a gesture towards trust in what a sense of community can accomplish. In its ideal form, group art becomes more than a way of making art and can even serve as a model for life itself. To maintain its vitality, art must periodically be redefined. When teachers engage in participatory art, they redefine art education by shifting attention from the private product to a public mode of operation. The dynamics of collaboration assures the teacher that whatever emerges will bear the distinctive mark of the group.

Whatever occurs when people work together, the results will be impossible to "copy." If a thousand chalk-ins were done simultaneously through the country, they would all be different. Peter London, a long time supporter of group art has written:

"The premise of the group art projects that I've worked out of is that there is a real shift in kind as more people involve themselves with the dynamics of group process. Too, the individual when he participates in a group, exhibits a different constellation of characteristics than when he acts alone. This later fact is of great importance for the Art teacher who assumes any responsibility for the personal and social development of his students.

Aside from the sociology and psychology of group dynamics in art, on purely formalistic grounds, the process allows for the consideration of variables outside the realm of most solo enterprises. Group art always involves a complex social and physical dynamic, wherein the planning, performance, or execution of the event is complicated by increased numbers of perceptions, egos, discrimination, values, et al. This usually causes the event to take up more time, space, materials, and circumstances than the typical piece of art done individually. In short, as group art becomes public it becomes theater, variables such as space, time, atmosphere, movement, sound, costume, speech, gesture must be critically observed and integrated by the participants. The demonstration of the integration and interdependency of the elements and modes of art is made immediately apparent.

Group art can enable one to deal rigorously and unsentimentally with themes and emotions not simply dealt with by the single work of a single person. The single piece of art is like a sign, a signal indicated abstract and general expressions. Group art enterprises, may deal in time as duration, rather

than time as instant, and can exhibit abstract qualities of contrast and transition while still being specific at any one instant. Single piece art cannot do so.

Finally, in this brief description of general premises, group art permits a level of communication amongst a quantity of people again not easily made available to individuals. No substitution for the private enterprise of creative endeavors, group art undertakings are simply a powerful and "other" media for the artist — and art teacher."[10]

The following graph is a summary of the scope of the activities discussed.

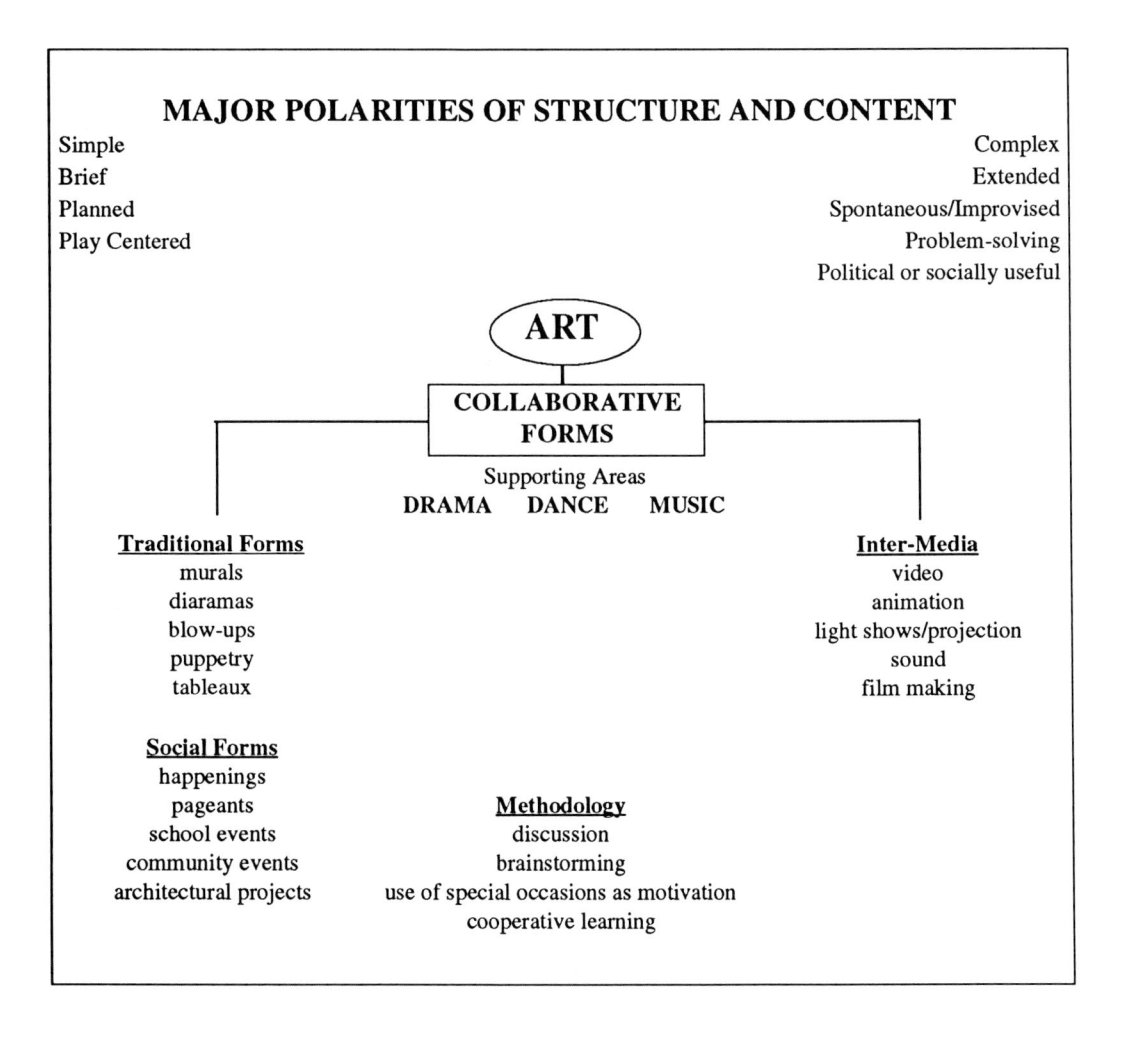

Some teachers question group art because it minimizes the role of the individual in favor of the group. The history of art in this century, goes the argument, was created by individualists, and the greatest breakthroughs have been made by idiosyncratic visionaries such as Picasso and Jackson Pollack who worked alone — never in collaboration with others. Not all critics support this view.

If Alan Kaprow served as an apostle of group art of the 60's, Suzi Gablik[11], in her book *The Reenchantment of Art*, is the spokesperson of the 90's for collaborative events as art with a social conscience. Gablik envisions artists working singly or in groups who will reject the egocentric basis of modernism in order to create works which can satisfy both social and aesthetic needs. Lucy Lippard in writing of the political side of "process oriented art," sees it as "an aesthetic idea grounded in a rejection of the self sufficiency of the work of art."[12] Those who play a key role in determining the functions and forms of such efforts must be capable of submerging their egos to serve some larger end. In speaking of the limitations of what is perceived as the excesses of "autonomous individualism" Gablik writes, "increasingly there is an emptiness at the core of this ego-centered desire for autonomy, the cost of which has been a diminished sense of community, a loss of social commitments." Gablik then cites the case of Bradley McCallum a sculptor who abandoned "large, rather distinctive objects in welded steel" for using skills and talents to work with the homeless to create shelter forms, and in the following passage makes a case for the artists of the future:

"We are in transitional times, an undefined period between detachment from the old and attachment to the new. It is a good moment to attend to the delineation of goals, as more and more people now imagine that our present system can be replaced by something better: egocentric values; whole-systems thinking; a developed discipline of caring; an individualism that is not purely individual but is grounded in social relationships and also promotes community and welfare of the whole; and expanded vision of art as a social practice and not just a disembodied eye. I have tried to show that none of these intentions is irrelevant to a value-based art, and that all of them are crucial to its reenchantment."[13]

Gablik and Lippard are not alone in their advocacy for an aesthetic that questions the modernist position of the artist as exemplary individualist. Twenty-one years earlier, Susan Sontag, whose social agenda while not as pronounced as Gablik's, wrote: "What we are getting is not the demise of art, but a transformation of the function of art…Art today is a new kind of instrument, an instrument for modifying consciousness and organizing new modes of sensibility."[14]

COOPERATIVE LEARNING IN ART: Students as Learners

Although this book is concerned largely with an approach to art making, the ways in which the processes of collaborative production can be applied to cooperative learning should be mentioned.

Cooperative learning involves small (4 or 5) mixed ability groups working together to achieve a goal. When teachers capitalize upon the dynamics of group work to facilitate learning, it is called cooperative learning. As Robert Slavin, a major spokesperson for this style of instruction reminds us, "The age of cooperation is approaching. From Alaska to California to New York from Australia to Britain to Norway to Israel, teachers and administrators are discovering an untapped resource for accelerating students' achievement: the students themselves. There is now substantial evidence that students working together in small cooperative groups can master material presented by the teachers better than can students working on their own."[15]

Although Slavin speaks for the contemporary educator, the idea of learning through groups is not new. In 1966, Ragan and Standler, wrote: "Children learn from one another through sharing ideas; group action is more effective when several individuals have shared in the planning; individuals find a place in group projects for making contributions in line with special talents; and morale is higher when children work together cooperatively on group projects."[16]

Cooperative learning involves every class member. The most skillfully conducted class discussion cannot eliminate the reluctance of the shy and the disinterested to participate. In a class of thirty, the constraints of time may not allow for student input on an individual basis. Cooperative learning makes it easier for a student to state a point of view as a member of a team than as a member of a class. In Slavin's view, "In a traditional classroom, students who don't understand what is going on can scrunch down in their seats and hope the teacher won't call on them. In a cooperative team, there is nowhere to hide."[17] Group art shares with cooperative learning that critical social dimension which can facilitate the ways in which students learn.

EXAMPLES OF COOPERATIVE LEARNING

Since photographs of class discussions are not visually interesting, the following examples of cooperative learning in art will be described.

Devil's Advocate

The following lesson occurred in a high school observed in Utah. I'll call the lesson "Devil's Advocate." It was presented as part of a unit on aesthetics and began with a general discussion of a problem faced by the community. It appeared that a group of paintings donated to the city council by a local artist

were under question. As is so often the case, some members of the council found the content of some of the works objectionable. The teacher divided the class into groups and asked each to deal with the situation by focusing upon a different point of view. Each group had ten minutes to "role play" an advocacy position for the assigned point of view. Students were asked to distance themselves from their own personal biases so that reason might triumph over emotion. "It doesn't matter if you agree or disagree with the ruling of the council," said the teacher, "it may be both. In fact, if you have to come up with arguments that run counter to your feelings, remember that this is what lawyers and debaters do all the time."

The issues which emerged which relate to philosophy or aesthetics were assigned as follows:

1. The freedom of the artist is what is at stake, and the actions of the council is, in reality, a form of censorship.

2. The artist has a responsibility to society, and one of these is to respect the mores of the community which must live with his/her work.

3. The public should understand that artists are often a step ahead of public taste and should be prepared to live with works for a period of time before making a judgment.

When ten minutes had elapsed, each group defended its point of view — even when it opposed their own convictions. "Devil's Advocate" can be "played" in another way: a teacher can assign a different task for each group or using only two questions, ask two groups to address the same problem in order to compare concurrence and difference in arguments used by the two teams.

Interpreting Art Works

The three main components of this activity are the art work, the group, and the task which is to interpret an art work citing the ways in which principles and elements of art, such as line, color, pattern and rhythm, have been used to *support the meaning of the work*. Each team appoints its own "spokesperson" who reports to the class the conclusions reached by his group.

When all groups work from the same image, interpretations can be compared. When teams work from a variety of reproductions or tasks, comparing results is more difficult. This is not to say that such an approach is without value; it is simply not as effective a learning tool as maintaining consistency between task and image.

Searching for Structure

I have written elsewhere of an analytical process which involves projecting a slide of an art work on the blackboard and asking each student to chalk directional lines directly on the projected image.[18] When the lights are turned on, the "skeleton" of the work is revealed and can be read as an abstraction of the original. When overhead projectors are available, each student using a photocopy of the same image can make an individual drawing on acetate or clear plastic. When all of the acetates are placed one on top of the other on the projector, the class can study where there is visual consensus, where some students have veered off on their own, and where some have recorded *implied* directions rather than those which are clearly stated.

Searching for Style

In "Searching For Style," the teacher shows the class two or three reproductions of works by the same artist. Following the procedure described in "Interpreting Art Works," the class is divided into groups and asked to write down any principles or elements of art that are shared by the reproductions. When each group has completed its inventory, the characteristics are listed on the blackboard as each leader reads the results of his team to the class. As an example, a group of paintings by Miro can be identified by the use of lines painted on flat surface with some shapes painted black and some red — all presented without shading of any sort. A group of Persian manuscripts might show an extension of a portion of the subject beyond the border of the picture, the use of calligraphy, gold leaf, flat space, hard edges, and patterning. The activity can end at this point and serve as part of an art history lesson or it can provide the basis for a studio activities.

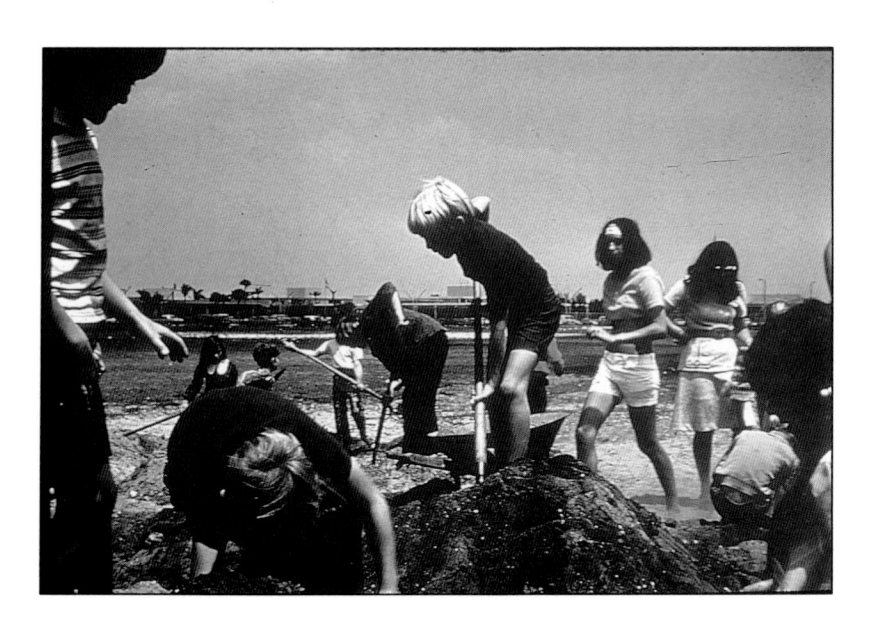

EARTHWORKS—*Earth, (not to be confused with dirt) is inexpensive and can be modeled by pressure and by adding and removing portions of the material. Bricks and boards when used as shaping tools can create flatness and provide contrast with softer mound-like shapes. Ditches move the eye below the earth's surface and also provide crawl spaces for participants. (Examples shown are from Japan)*

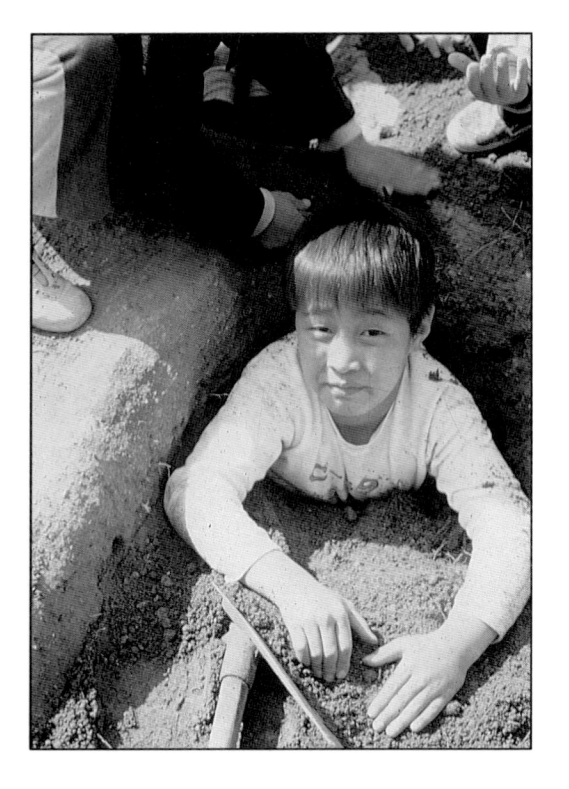

PLAYGROUND EQUIPMENT AS A LOOM (right)—A group of children use a piece of playground equipment to weave connections among the metal supports. When viewed from a distance, it was seen as a total work; but upon closer inspection, it became evident that many sections had their own style. Some were more intricate than others, some more open, some concentrated on knotting while others used spider webs as models.

SPONTANEOUS SCULPTURE WITH FOUND OBJECTS (bottom, left)—Neighborhood children brought the debris of the street to the studio of a local architect and under his guidance, assembled what they called a "Street Dragon." Anyone was welcome to participate as long as they contributed junk or cast-off materials to the work which eventually included the addition of color and poetry. (bottom, right) A New England art teacher took her students on a field trip for outdoor sketching.

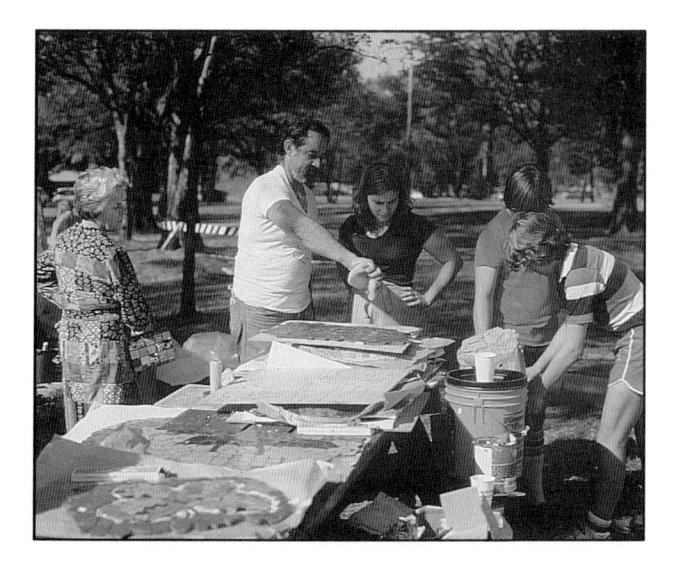

NASHVILLE'S SERPENT: **Group Art as Permanent Fixtures**—*Pedro Silva's "Sea Serpent" located in the Fannie Mae Dees Park in Nashville, Tennessee was executed in cement surfaced with mosaic. The number of adults and children who participated in its construction (over one thousand) and the range of supporters who funded the work (Tennessee Arts Commission, Vanderbilt University, City Parks Department) make this a model of collaboration between children, adults and local institutions.*

THE CERAMIC MOSAIC MURAL—*Lily Ann Rosenberg, like Pedro Silva, is a community centered artist. Both are expert at getting aesthetic adrenaline flowing in participants of all ages. These illustrations show how the artist helps children organize their efforts (both sculptural and mosaic) to make their school more attractive.*

18

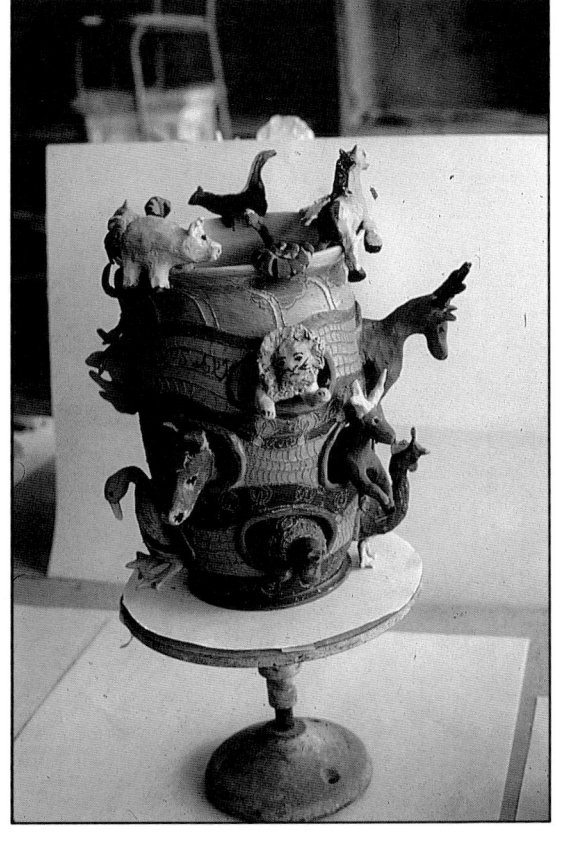

ANIMAL POTS AND OTHER FORMS OF CONTAINER SCULPTURE—*In "Demons and Devils," somebody—teacher or student—selects a work featuring a variety of imaginative creatures. Examples of some such sources are Pieter Breugal the Elder's "Temptations of St. Anthony," the works of Hieronymous Bosch and Mathias Grunewald, all of which abound in bizarre, demonic images. Teams of students working from xeroxes of the same picture or from an assortment of reproductions. They can also create their own synthesis of several examples. These are then modeled in clay and when completed, displayed in an appropriate setting, such as a group of charred wood or a piece of driftwood. Since a unified work is the goal of the project, students are not able to remove their works, and are usually content to donate their efforts to the art room. In this illustration, five students have applied animal forms to a large ceramic container "thrown" by a student teacher.*

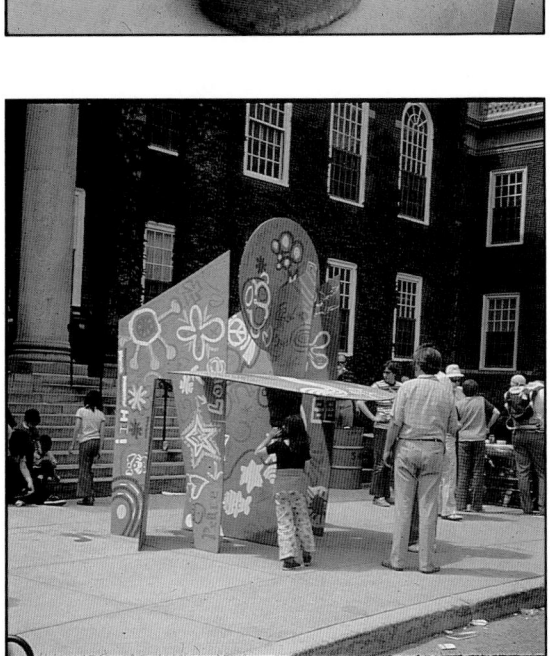

INVOLVING THE COMMUNITY: SCULPTURE FOR THE FOURTH OF JULY—*As part of the community's Fourth of July celebration, I designed free-standing sculpture out of heavy cardboard and placed brushes and containers of red, white, and blue acrylic paint donated by a manufacturer. Onlookers were invited to decorate the sections in any way that suited them.*

19

THE 60's AS CULTURAL SETTING
FOR GROUP ART

In studying collaborative/group activities which go beyond conventional forms (murals, puppetry and dioramas), one can not avoid that hot bed of social and artistic ferment — the 60's. Major events which accelerated tensions among America's youth and which had repercussions in education and the arts were the Cuban missile crisis (1962), the assassinations of President Kennedy in 1963 and Martin Luther King in 1968. The escalation of American intervention in Vietnam was well underway the year Malcom X was assassinated, and in the same year, Martin Luther King and Robert Kennedy were both assassinated. In 1968, Chicago experienced its first major police riot at the Democratic Convention, and a year later protests against the war in Vietnam were accelerated throughout the U.S. Trials of dissidents such as the "Chicago Eight" set the stage for the campus unrest and led to militant gestures such as student takeovers of administrative offices of colleges and universities. Resistance to the draft and other activist expressions of resentment spread as America's failure to reform American society along humane lines fueled the fires of discontent. Although most artists participated in the political drama that was being played out on campus and in the streets, the majority of them maintained a separation between their artistic lives and their political conscience. Some, however, felt that new politics called for new art forms and, in the search for an aesthetic more relevant to the times, attention was directed to the arts of performance and technology. Much of the change the art world was undergoing was of real benefit to the public.

Diane Crane noting the rapid pace of growth in the American art scene in the post-World War II era, wrote that in New York alone,

"Museums added space and activities devoted to modern art; galleries handling modern art increased from 20 to 300; from a dozen or so, the number of serious modern art collectors grew to thousands; exhibitions by painters increased by 50 percent; according to some estimates, the number of people calling themselves artists grew from 600,000 in 1970 to over a million by 1980; while outside of New York, new public, corporate, or university museums were established, and the federal government became a major supporter of cultural activities."[19]

In the *64th Yearbook of the National Society for the Study of Education*, James Schinneler attempted in the brief space allotted him, to inventory the dominant art tendencies (pop art and abstract expressionism) in the art and architecture of the mid 60's. Little attention was devoted to Hard Edge painters, regional groups such as Chicago's socially conscious "monster school," and

the figurative Bay Area artists. Also not included was Alan Kaprow's "Happenings" and environmental works and events which were part of the move to bring about a closer integration between art and life or to be more specific, between artist and viewer.

No one exemplified the desire to close the gap between performer and audience more that Robert Rauschenberg who began as an abstract expressionist painter in the 50's. In the 60's, Rauschenberg not only combined painting with college and real objects but was involved in performance, happenings, environmental works, dance and experiments in intermedia which he combined in a variety of forms. If any one figure could be said to be the exemplary boundary breaker of the 60's, it was he. Art educators could always make a case for the artist-as-model as long as they worked from traditional modes of art; advocates for experimentation such as Jim Dine, Rauschenberg or Claus Oldenberg were harder to come by in the art rooms of America. The conception of the artist-as-model, it seems, was more selective than many cared to admit. If performance artists, conceptual artists, earth artists, political activists, and aesthetic mavericks in general maintained a lively presence in the art world, art educators felt more comfortable working with craftspeople, water-colorists, printmakers and others who worked in more familiar modes of expression.

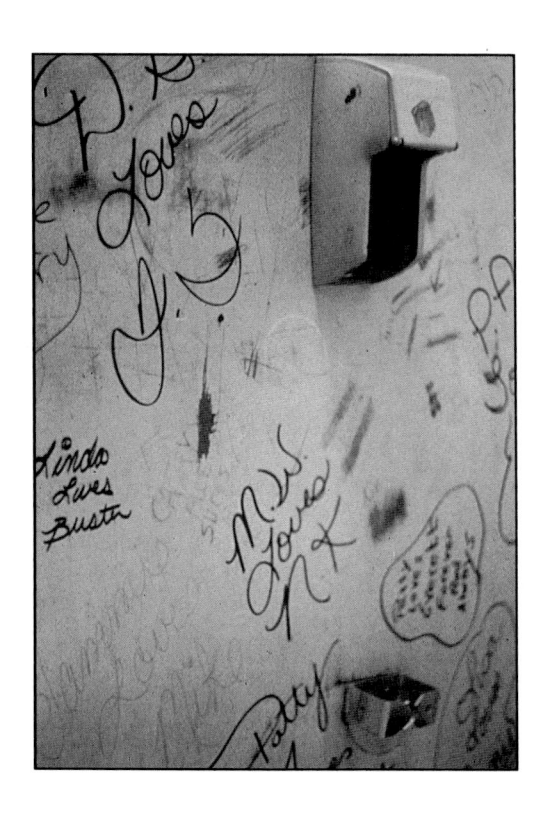

Decorating a school bus (page 23) is one sure way of reminding the community of their art program. The class that assumed responsibility for the project spent a great deal of time critiquing sketches. Their goal was to make the stripes of a tiger (the school's logo) compatible with the shape of the vehicle. (left) Another socially useful activity resulted from another teacher's impatience with bathroom graffiti. This led to a series of paintings on the door of each stall. There is a question of aesthetics here. If each panel is conceived and exhibited as the work of an individual student, does the same painting when used for a practical purpose become a lesser form of art? Sherry Hodges and Rebecca Sharp respectively were the teachers for the bus and bathroom projects. (below and on cover) Students appear to be engulfed by their logo as they paint a mural segment of the same subject for the cafeteria.

24

SPACE CONVERSION AS CURRICULUM (above)—When an art teacher in Brookline High School was given a huge empty space (in this case, a gymnasium) she saw it as an opportunity to plan an art program around the conversion of one function to another and used the space as a focal point for group activities that could contribute to the whole school. Students selected activities which appealed to them. Functioning as designers, painters, weavers, builders they worked from a plan that came about through cooperative planning. They also raised the money for supplies and carpeting. A full school year passed before the transition from gym to student center was completed. To the rest of the school, the new lounge was a constant reminder of the presence of the art department and the capability of art to improve the quality of student life. In this figure, students are applying stenciled shapes to create a border.

COLLABORATION FOR COMMUNITY SERVICE (page 24, top)—The art class at Phillips Academy in Andover, MA, chose as a project the creation of an adventure playground for a nearby park. In addition to planning and executing the park, the group had to go before the town planning board for permission. They also had and to raise the money for materials as well as design and construct the play forms.

ENVIRONMENTAL IMPROVEMENT (page 24, bottom)—A sculptor in residence in a small rural school in Alabama used his expertise to transform the setting of the school. The students created the ceramic sculpture, learned masonry skills to create a circular base and lay down a patio. Although the artist was not trained in landscape design or any aspect of architectural planning, he applied his knowledge of materials and sense of design to help these middle school students make their school a better place for living and learning.

ART EDUCATION IN THE 60's

There were a number of strands in art education which dominated the late 60's and early 70's. There was a subject content or discipline centered group, an aesthetic education movement which stressed the experiential rather than the cognitive aspects of art, and there was a minority who attempted to bring the avante-garde of the art world closer to the schools. There were predictable, run of the mill programs described by Arthur Efland in his essay "School Art and its Social Origins"[20] and high levels of inspired teaching which included various combinations and balances among the many components of an exemplary art program. The university based academics had their eyes on improving and redefining curricula, and the aesthetic educators looked beyond the schools towards community agencies, drawing much of their support from foundations and federal programs. Underlying all attempts to improve the profession was the increased interest in the ways art would better serve neglected populations such as the urban disadvantaged, children with disabilities and a growing awareness of multicultural diversity.

The art education establishment during this period was, as usual, responsive to forces beyond its own domain. The curriculum reform movement was set in motion as a result of the USSR's successful launching of sputnik (1957) which in turn led to the influence of scientific models of learning in the general reform movement that was to follow. Jerome Bruner's *Process of Education* took a new look at learning theory and was followed by a series of programs begun as a result of President Kennedy's appointment of August Hecksher as Special Council of the Arts to the White House. Hecksher appointed Francis Keppel as U.S. Commissioner of Education, who in turn, invited Katherine Bloom to serve as Arts and Humanities Advisor.

When Bloom became Director of the Arts in Education for the John D. Rockefeller III Fund, she had an opportunity to put into practice a set of long held beliefs. The Arts in Education movement was more of a philosophy than a curriculum or a theory and could be reduced to one phrase, "All of the Arts for All of the children." As Stanley Madeja wrote, "Kathryn Bloom's approach to the arts was somewhat simplistic, but very effective in terms of explaining itself to various constituencies...What (she) was attempting to do was to support the disciplines in each of the arts and broaden their impact or base within the general education curriculum so that they reached more than just the talented or interested in art."[21] Ultimately, it was up to those supervisors, teachers, and research and development centers such as CEMREL (Central Midwestern Regional Educational Laboratory) who were the recipients of the new grants to implement Bloom's philosophy in ways that could best work on the local level. In this way, a few groups were able to sponsor

projects which could capture some of the interest in group art and intermedia which caught the imagination of artists operating outside the schools. One example was Stanley Madeja's design of the "Space Place," one of the first settings for large scale participatory activity for children (Fig. 1, page 6). Mary Frates, a museum docent recalls her first impressions, as follows: "I didn't understand it or like it much. I disapproved of the holes in the museum walls which held the elastic grid system of the ceilings, the debris from the styrofoam blocks which kids used to hit each other over the head, and the utter confusion it caused in any sponsoring museum."[22] If the "space place" could not be tamed for a museum setting, it doubtless would have found even less of a welcome in most public schools.

The Woods Hole conference of 1959 began a shift in philosophy in which many of us are still involved. Manuel Barkan, a key figure in the changes that were to come about, felt Jerome Bruner's theories regarding structure, content and learning could be transferred to art education and at the Penn State Seminar (1966) he (Barkan) made a case for art education as a composite of disciplines made up of adjoining domains of content. Add to this Elliot Eisner's argument for the study of art appreciation in the Sixty-fourth Yearbook of the NSSE in 1965, the publication of Ralph Smith's *Aesthetics and Criticism in Art Education* in 1966, and the appearance of elementary textbooks and guidelines for television instruction — all of which stressed the accommodation of critical and historical areas into studio activity, it was inevitable that repercussions began to be felt in state and local guidelines, and, ultimately, the classroom.[23]

The concern for content based structure continued into the 70's through the behavioral goals and accountability movements. Efland wrote, "With the decline in scores from 1964 through the mid 70's, accountability pressures became a social mandate...by the late 70's the rhetoric of instructional objective was ubiquitous."[24]

Since the seeds for content based art education were planted well before the 70's, it is understandable why collaborative art activity, with its emphasis upon shared rather than individual learning, and sensory affectively based experience, was given short shrift by the art education establishment.

The critical stance of art educators towards their profession has traditionally been positive, directing itself towards improving rather than condemning existing practice. There were, however, two critics of the period whose judgments were, to put it mildly, severe. In 1963, David Manzella's *Educationists and the Evisceration of Art Education* took the profession to task for not placing artists and artistic processes at the core of the curriculum. Howard Conant, Chairman of the Department of Art Education at New York University, was even more censorious in his judgment of the state of art education, describing

it as "basically meaningless, culturally purposeless, artistically ludicrous" and "it has so little to do with art, and is, in fact, so downright bad it should probably be suspended."

Conant's vision of what a more rigorous art education could and should be was prophetic in its anticipation of what currently passes for discipline based art. If Conant was adamant about what was wrong with art education, he was clear in what he believed was needed. As the 60's drew to a close, he wrote:

"What is needed, of course, is a balanced art educational program in which all major historic and contemporary art forms are studied in the fullest possible cultural context, augmented by personal creative work in media pertinent to each period style, and medium.

...How welcome indeed, and how potentially fruitful, might have been an Ingres-like focus upon the discipline of representational drawing, a Hofmannesque exploration of explosive creativity in painting, or a Cornellian exploration of the mystique of surrealist constructions. And how deeply rewarding might have been truly concentrated studies of primordial imagery in abstract painting, penetrating studies of archetypal form preferences as possible bases of art-style choice, or detailed investigations of physiological responses to various types of iconography."[25]

Conant was critical of "The avant-garde sympathizers (such as myself)...almost too closely in touch with students' current and often transitory interests."[26] He took art educators to task for excluding "architecture, environmental design film, videotape, the interdisciplinary arts" all of which to my thinking clearly reflected the interests of students at the time and which supported in the context of collaborative activity.

Nowhere was the interests of our secondary students more vividly represented than in NAEA's "Vision and Communication" conference held in 1968 in New York City.

VISION AND COMMUNICATION

One source of the history of art education that has suffered neglect is the content of regional, state, and national conferences.[27] "Vision and Communication," was an Eastern Regional meeting held in New York City under the auspices of the NAEA. It set the stage for today's discipline based philosophy as well as the growing interest in technology and the uses of newer media, (the title of the conference held in 1966).[28] The conference not only featured such nationally known art educators as June

King McFee, Manual Barkan, and Stanley Madeja, but "outsiders" such as educational critic Jonathan Kozol and psychologist Robert Coles — both still actively engaged as observers of the educational scene. Also present were artists Red Grooms and Romare Bearden, critics such as Harold Rosenberg, and Willi Kluver, a major spokesperson for the art and technology movement. A performance artist integrated a poetry reading with ten video screens while another, using simultaneous viewing on three large screens condensed a day in the life of three major networks into an hour's presentation. John Cataldo, my co-program director, arranged for the first televised communication with Canada; workshops in film animation were offered, a new high school course centered on the creative uses of light was showcased and David Manzella prepared what was to be NAEA's first (and last) exhibition of erotic art. The riots in New York which followed the assassination of Martin Luther King led to the mugging of two of the conference participants, adding to a general sense of crisis. Speakers beyond the pale of art education participated without fees, sensing that the time had come to bring together in one setting those diverse threads of interest that set art education apart from other areas of the curriculum. The credibility enjoyed by mathematics and science teachers may have been higher than that of art education, but when it came to adrenaline, we were the leaders—at least in the Vision and Communication Conference. All in all, this was one convention that managed to convey something of the sense of ferment, of openness to new liaisons among the arts and the possibilities offered by the technology of communications that was so much a part of the prevailing zeitgeist of the 60's.

When the meeting was over, teachers returned to their classrooms in the small towns, rural areas or cities of their regions. Some undoubtedly succeeded in incorporating ideas of the conference into their teaching, while others tried, but for one reason or another, failed to make the transition. What "Vision and Communication" offered all participants was a picture of what art education could be, of territories waiting to be explored. While most teachers continued to operate as though the convention had never occurred, the artistic and social forces which were responsible for much of "Visual Communication" continued to grow — particularly in the urban, suburban, and academic centers of the country.

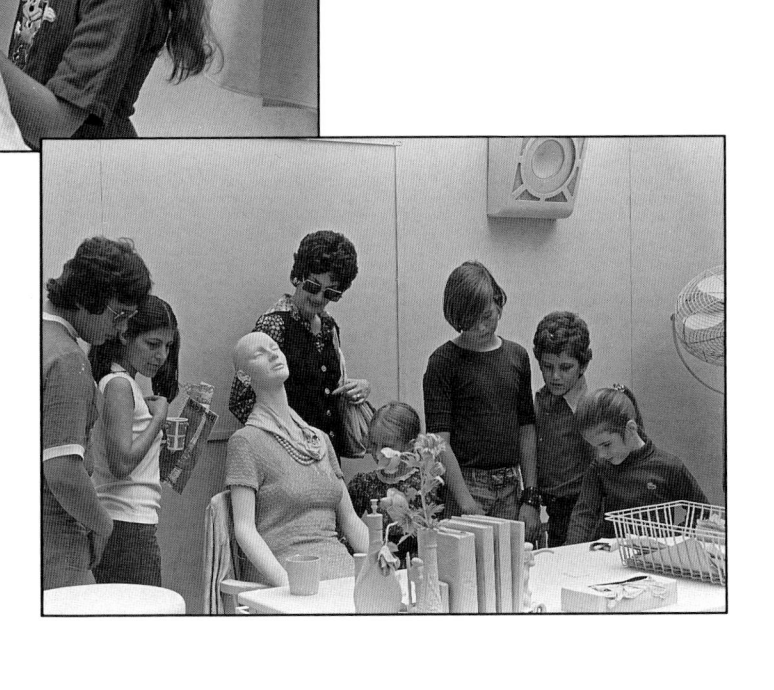

THE LITTLE RED SCHOOL HOUSE—*The Little Red School House was a collaborative project designed by students at the Houston High School for the Visual and Performing Arts. Under the direction of art teachers Karen Carroll and Annette Wagisback, students built a classroom environment to express their ideas about the state of education. The total environment, including the teacher and students were painted institutional green—except for what could be seen going on in each mind and was visible through a clear globe in the top of each head.*

COMMUNITY PLANNING—Community planning can be imaginary (as in housing a group of aliens) or practical, as in studying ways of understanding one's town or city. When made to scale, the use of mathematics becomes part of the problem. Connections between art and social studies also become easier to study. A segment of a city turned into a setting for a clay animation film is illustrated above (top, opposite page). A class of third graders in Nebraska studies everything from such practical matters as zoning and the role of the city council to problems of beautification (above). A 5th grade teacher worked with the art consultant to create their town planned to scale (bottom, opposite page).

A MIDEASTERN VILLAGE (above)—*The Mideast has many abandoned villages made of mud and wattle. (Morshakor and the fortress city of Bam in Iran are two prime examples.) I used my slides taken in Iran to bring this sculptural approach to architecture to a 5th grade class. The vocabulary of form is simple; if you can make a slab and a pinch pot, you can make the kind of village that could have been encountered by travelers on the silk road from China through the Mideast. Students working in teams or by themselves made their own segment composed of walls, doorways, domes, parapets and arcades then joined them to create a community. (Roloff Beny, photographer)*

DOMES (page 34)—*Middle school art students build a geodesic dome. Buckminster Fuller, a visionary architect, engineer, poet, philosopher, and futurist, popularized the form and was a guru figure of the '60s and early '70s. The geodesic structure made its debut in Montreal's Expo '67. The materials used by these students was cardboard tubing supplied by a carpet manufacturer. Paper panels were later added to supply a "skin" for the structure.*

THE DILEMMAS OF TRANSITION:
A PERSONAL NOTE

My interest in group art accelerated when I moved to the schools of Newton, Massachusetts. Prior to that I worked in Dade County, Florida as an art teacher on the elementary and secondary levels and as an art teacher on television. An appointment as Supervisor of Art followed in 1955 and in 1966 I was offered a joint appointment as Coordinator of Visual and Performing Arts in Newton, Massachusetts and Associate in Education at the Harvard Graduate School of Education. I accepted the offer for many reasons, among them Newton's reputation as a forward looking school system, and the opportunity this offered to work in theatre arts; an area in which I had a strong interest. I held an MFA from Yale School of Drama and my professional experience ranged from serving as Leonard Bernstein's general manager to producing everything from summer theatre to Off Broadway to hotel supper theatres. I was also ready to move from Dade County, the country's sixth largest school system to a small city with only 28 schools. (Supervisors who think they can sustain personal relationships with 185 art teachers spread over a 50 mile radius are deluding themselves.) What I didn't foresee was that administering three subject areas (music, drama, and art) in a small system could be as unmanageable as overseeing a single subject in a district the size of Dade County. I arrived in Newton ready to enter a new phase of my career. I was prepared for some of what lay ahead, but what I did not anticipate was the intensity of the youth culture being shaped by everyone who in some way was a part of the social and political activity that eddied around the Cambridge-Boston-Newton axis.

The art program in Newton was in no need of repair — my predecessor, Eleanor Elliot, saw to it that its operational aspects went far beyond what might be considered minimal requirements. Funding for supplies and resource materials was above average, the central office not only had a professional library, but a collection of original paintings and crafts objects from many cultures. There was however, no central curriculum guide from which the teachers worked and due to a philosophy that stressed the leadership of classroom teachers rather than art specialists, one art consultant was shared by five elementary schools. What Newton possessed was a group of teachers trained to function independently with a strong allegiance to their schools and students rather than to each other. The first thing I did in availing myself of the "honeymoon" period that came with being a new administrator was to double the number of elementary art staff. The second was the think about what I as a supervisor could contribute to the betterment of the art program. It was in my search for a missing element in the curriculum that I began paying closer attention to artists, because they were the ones who drew me to a

way of thinking about art that could provide a link to Newton's art program — the overlapping worlds of media, performance events, and collaborative activity.

While the educational climate in Newton was more open to change than most school systems, it was still an institution supported by public taxes, and subject to the values and mores of the community. It soon became clear that the addition of a collaborative dimension to the existing art program would have to follow a different path from that used by most administrators. Group art in the form of mural making and puppetry and dioramas were accepted not only in Newton, but in most elementary schools in the country. The kinds of participatory art in which I was interested were more difficult to include in the usual curriculum formats. It is one thing to suggest a cut paper mural as an activity for the 4th grade, it is something else to suggest an earthwork or a large scale wrapping project a la Christo.

There were other problems with including group art as an accepted member of the art curriculum. For one thing, results could never be replicated. Group art had no clear methodology, nor did it have a clear context in existing curricula and because of its essentially hybrid nature was resistent to the conventional modes of assessment. How does one grade a parade? *Ought* a parade be graded despite the fact that students plan and execute costumes, masks, floats, etc? Can any community-centered activity be considered as part of a curriculum? When group art began to take hold in Newton, the process of development followed a relatively conventional pattern and included: 1) written statement of a rationale; 2) identification of the teachers who were prepared to open their programs to new forms of collaborative art; 3) discussions, workshops, demonstrations, and consultations with specialists; 4) piloting ideas through special classes for children in summer and Saturday mornings; 5) supporting teachers who had specific projects or courses in mind; 6) showcasing teachers at staff meetings and conferences; 7) participation in events in Newton, Cambridge, and Boston which reflected collaborative efforts between school, community and artists; and 8) hiring teachers and visiting artists with a professed interest in group art, newer media, performance, etc.

I joined the Newton staff at a time when vernacular arts (costumes, body painting, concerts, improvisations, mock funerals, and the like) made aesthetic events out of rallies, marches, sit-ins or teach-ins. As street art merged with "serious" art, graffiti artists, the bane of the urbanite, were invited to "perform" in galleries. The mix of talent and the raw energy that too often paraded as artistry was as diverse as it was fluid, and attempts to apply any sort of constraint upon it would have been doomed to failure. In retrospect, I realize I exaggerated the extent of Boston's position as a flagship for the youth move-

ment. Berkeley, Columbia University, and other centers of Ivy League angst were energy centers of militancy to be sure, but Boston had more institutions of higher education than any city in the world (over thirty at the time) and so powerful was the impact of youth culture, it was easy to assume that what happened in Massachusetts existed with equal intensity throughout the country.

Most supervisors and teachers at the time were content to carry on art programs as though nothing had changed in the past decade, but then I didn't move from Florida to New England to conduct business as usual. The basic problem lay in creating something of educational value out of a culture led by a bewildering array of political and artistic talents many of whom were frankly hostile to the process of schooling. As an arts administrator, I clearly bore the stigma of the Establishment. How does an administrator go about taming a beast that is ready to tear the house down?

Is it even possible, I asked myself, to involve an essentially conservative institution such as the schools in what one critic described as "a search...for the new, the vital, the inspired, the unconventional?"[29]

The anger and frustration which helped create the counter culture, often used the ideas of artists to further political ends. The impulse which held promise for me was the kind of collaborative attitude Gregoire Muller described in his *"The New Avant-Garde"* when he wrote: "The 1960's were characterized by a deep identity and language crisis that troubled Western civilization. The definitions and the essential entities and values of life were questioned, negated, and replaced by new ones. A whole counter culture based on music, political radicalism, drugs, and the writings of people such as Marshal McLuhan and Herbert Marcuse appeared."[30]

To Angiola Churchill, one of the few art educators with an interest in group art (happenings, in particular), Kulterman's statement pointed to a "purpose...to create a new awareness not possible in the realm of the traditional arts. By breaking away from the much rehearsed, tight patterns to which our senses are accustomed, we begin to respond more intensely to what others are doing, to what is happening either solo or as a group...It is perhaps the group energy involved that makes this active form (happenings) so appealing to children."[31]

In an editorial for *Arts and Activities* magazine, Vincent Lanier wrote:

"If a Happening is symbolic at all, it is symbolic of the absurdity and the ambiguity of human existence. The Happening, its light show and its electronic music, become fundamentally accident art — irrational, non-sequential and, in one sense, anti-rational art. Happenings have no plan; they are imper-

manent; they should not be repeated. They are moments of intensified experience."[32]

While Lanier is certainly correct in part of his statement, some of his comments conflict with my own experiences in the events in which I participated — both planned and directed (if that is the word) by Alan Kaprow. When accidents did happen, they occurred within a scripted context and contrary to instilling a sense of the absurdity of life, the events were designed to heighten an awareness of commonplace objects and behaviors. This is not to say that Lanier and Churchill's definitions are incorrect; it does show how meanings change as new ideas gain popular acceptance. ("Creativity" and the currently popular "aesthetics" can also be cited in this regard.) Kaprow's events—at least the two in which I participated—were clearly geared for reflection rather than the boisterously expressive view that was held by the general public.

Advocates of the "new avant garde" too often failed to mention the negative aspects. The untrammeled freedom that students enjoyed degenerated too easily into nihilism and anarchy. How could a liberated teenage ignore the sexual revolution and the emergence of nudity in the theatre? Students did their spontaneous disrobing at mass rallies and rock concerts while their elders attended performances by the Living Theatre and plays such as "Oh Calcutta." Attempts at reasonable discourse were often shouted down as being "elitist" or "repressive" and freedom of speech, particularly at conferences, was aggressively denied anyone opposing the views of the majority. Teachers with Ph.D.'s were advising our brightest students to drop out of school on the grounds that formal education was no longer "relevant" and students who were flirting with drugs were making decisions which, in many cases, were to have disastrous effects on their future lives. Bumper stickers and banners of the 60's carried the slogans that students lived by - "Hell, no, we won't go," and "Hey, hey, LBJ, how many men did you kill today?" and "Don't trust anyone over thirty."

At the heart of most group activity at the time, was the growing desire for deeper interpersonal relationships. It attracted school drop outs, middle class college bound youth, teachers — anyone who felt disaffected or saw themselves in an adversarial state to society. The sense of alienation, accelerated by American's role in the Vietnam war, grew as students became increasingly more skeptical about the role that adults and their institutions played in controlling their lives. The most pervasive art forms to carry the message of the disaffected were known as intermedia events.

Marshall McLuhan's media theories provided a theoretical foundation for the growing interest not only in the uses of video, but in other technologically based media such as multiple slide projections and film making, all of which could be combined with mime, dance, and theatre. Such art forms

were known as the "intermedia," a major form of group art at the time, at least in major cities and centers of higher education. Intermedia was strongest on the university level and in commercial settings such as New York's "Electric Circus." With its many components, a full blown intermedia event was a latter version of Richard Wagner's vision of the "gesamtkunstwerk," that ultimate synthesis of art forms, the '60s generation updated Wagner with such additions as audience participation, nudity, marijuana, and an occasional riot added to further heighten the sense of drama.

The dark side of the counter culture was all too familiar to educators, particularly in suburban secondary schools, who had to deal with its residual effects in the classroom.

The total picture however, was not as bleak as it appeared, and as previously stated, I took it upon myself to search for positive aspects of the group art movement that I believed could justify a place in the art curriculum. Not a simple task, but one worthy of one's efforts.

In my attempt to work from both the arts of street and gallery, I had to make a separation between serious works whose overtones were socially positive and those which were potentially destructive. Sister Mary Corita taught us that communal art works could be uplifting as well as abrasive. Fourth of July events, school parades, weddings, inaugural rituals when imaginatively conceived and executed, could all move spectators from traditional to active roles of passive reaction. Corita was a new voice, not only in printmaking (silk screen), but in her joyous attitude toward life itself. She liberated many of us through her processions, her celebrations, and all communal rituals of which she was a part.

One example of an event with positive overtones in which our students were involved was Lowry Burgess's "Tulips," a Stonehenge-like arrangement of blocks of ice placed on the frozen surface of the Charles River in Cambridge. With the warmth of spring, the river thawed and the bulbs implanted in the blocks of ice were washed down stream to take root and blossom in the river bank. I felt this was a poetic ecological statement and was only too happy to arrange for students to assist Burgess in arranging his blocks of ice. (Conceptual artists, I discovered, are in perpetual need of free labor.) I rejected any group or individual associated with violence or events which assaulted the participants in some sado-masochistic way such as crucifixions, impaling objects in one's body, throwing people down stairways, etc.

LIGHT SHOWS *(pages 41, 42)—Basic instructional media found in most schools can be used to produce a light show. Projections are created from slides, cut paper silhouettes and colored transparent "gels" placed on overhead projectors. These can then be superimposed one on the other and projected on any surface—soft materials, people, screens or objects. Parachutes and sheets of mylar also make interesting surfaces. Anything through which light can pass can be used; from film run backward as well as forward to images drawn directly on film. Glass dishes or bowls with colored dyes floating on water or oil create "wet" movement. Music, from rock to electronic to Mozart, can accompany the large scale, brilliantly lit effects. When dance is added to sound and sight,then the light show becomes a rich sensory adjunct of an intermedia performance.*

(above) Projection techniques have been used in a middle school up-dated of Alice In WonderLand. *(page 42, top) A girl dances to one image projected within another. (page 42, bottom) Illustrates how overlapping images can be used.*

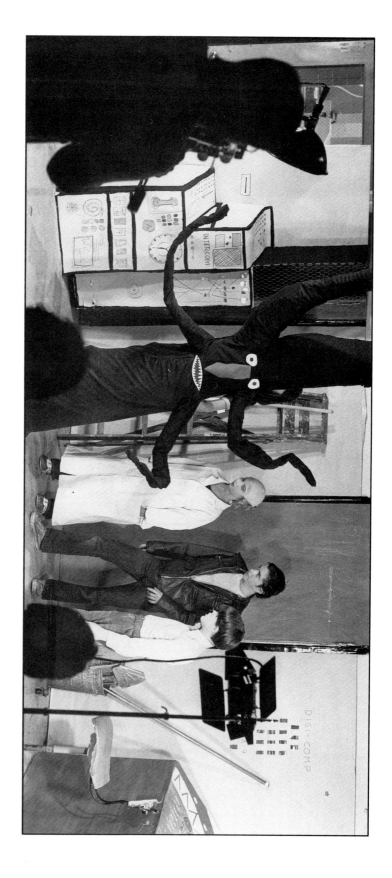

FILM ANIMATION —A scene from "A Day in the Life of John Doe" Pixilation has been going on from the early films of Melies to the Monty Python shows. Pixilation animates people as well as objects and works best in a collaborative setting because everything is life sized; the settings, properties and costumes. Such a film also requires script writing, photography, sound, make-up and editing. Although pixilation is often done out of doors, indoor settings, in general, permit a wider use of art skills. Animation is a valuable activity for many reasons; among them the use of pre-planning, the extended periods of concentration, and the need for arithmetic skills needed to convert frames-per-second to motion. It also encourages use of the imagination, and can call upon a variety of art abilities. As in architectural planning, film animation draws upon multiple modes of think-ing—logical, intuitive, artistic and practical. Yvonne Anderson, teacher.

43

A PORTABLE "ALICE" (top)—*The production of "Alice in Wonderland" was submitted for review as part of an Advanced Placement portfolio in studio art. The object was to create settings and costumes whose economy of design would enable the production to be transported to neighboring schools in a group of suit cases.*

NEW MEDIA (bottom)—*Although the phrase "new media" was originally associated with technology, its meaning can also apply to any material new to the artist. In this case the medium is balloons. A high school art class was divided into three groups and assigned three inexpensive materials balloons, yarn and tightly rolled sheets of newspaper with which to design an abstract setting for the school's dance group. The dancers discovered that the balloons not only were the most compatible with lighting effects, but when rubbed, added an element of sound.*

THE CUMMINGTON EXPERIENCE

In my impatience with those compromises which inevitably arise when working in public education, I began searching for ways to exercise my own freedom to choose. In 1969, I joined Arthur Hoener, a member of the department of painting at Massachusetts College of Art, in directing a summer program that would allow us to put our ideas into action. This was the Intermedia Center of the Cummington School of the Arts located in the Berkshires of Massachusetts. Arthur and I were interested to see what would happen when a group of creative personalities representing all of the arts elected to live together for 5 weeks in relative isolation. We were curious as to what kinds of art forms would emerge and the nature of the dynamics that would produce such works.

Our goal, according to our published statement of intent, was:

"…for students and teachers who feel a need to go beyond the conventional boundaries of the visual and performing arts. Cummington has planned a milieu wherein sculpture may merge with movement, film with dance; where drama may engage the audience with a repertoire of sensual stimuli; and where traditional barriers between the arts dissolve in the process of redefinition. …Cummington will provide an opportunity for students to work in combines, happenings, or assemblages; to investigate a range of media technology to include light, sound, and the projected image; indeed, the human form and personality itself may become a component of the enactment through choreography, dramatic games, improvisations, and prepared scenes. Cummington will provide a fluid situation where a student may one week investigate painted sculpture and the next discover himself participating in a classmate's complex arrangement of a multimedia art form. Cummington proposes a work-study environment created specifically for the investigation of the unknown in art."[33]

The school included film makers, architects, poets, actors, potters, painters, dancers, and drew its participants from high school teachers and students as well as faculties of higher education in art and drama. Uppermost in everyone's mind was one goal — to take an idea as far as it would go, without compromise or constraint. The following activities give a sense of the life of the center.

—The creation of a multimedia play written with actors, dancers, sound, light, and film equipment at the playwright's immediate disposal. This was an ongoing "event" that lasted for daily afternoon sessions for a two-week period.

—The "raku" (tea) ceremony rewritten in contemporary terms, with a gas-fired kiln built for the occasion.

—A Saturday night party to celebrate the arrival of light, board, and dimmer equipment; the workshop turned into a forest with stage settings and backgrounds for projected images.

—The workshop was converted into a series of levels, broken into segments by parachutes and yards of plastic. Participants moved on cue like chessmen as the playwright dictated moves that were related to a parable. Strobes and projections, both still and moving, were incorporated into the action.

—An environment created for play and poetry readings, participants seated formally on either side of rows of florescent tubes with pews and lights swathed in boughs of evergreen.

—A taped composition written for an electronic light board.

—A series of group improvisations that ultimately led to the realization the group was dealing with the murder scene in Macbeth. The exercises, which finally ended with a crescendo of improvised light, sound, and movement were carried out against Shakespeare's script.

—A midnight ritual on a mountaintop involving choral verse reading and the symbolic burning of huge wooden effigies symbolizing forces of constriction in our past.[34]

While the Cummington experience did little to solve administrative problems that awaited me in Newton, it did verify my belief that creative people working together with a free hand can surprise even themselves and that ultimately we were our best audience.

It was during the Cummington period that I considered a curricular shift that would be more attuned to the tenor of the time and have as its center collaborative works of all sorts based upon a greater sensitivity to social issues—all conveyed through a pervasive use of technology. The problem of change on this scale proved impractical for many reasons, not the least of them being my own inability to make a convincing case for a socially conscious curriculum using the collaborative model. It was an example of the reach exceeding the grasp. Eventually I settled for what could realistically be accomplished - the infusion of new ideas in an existing program by teachers who shared my enthusiasm for what lay beyond or apart from the schools.

46

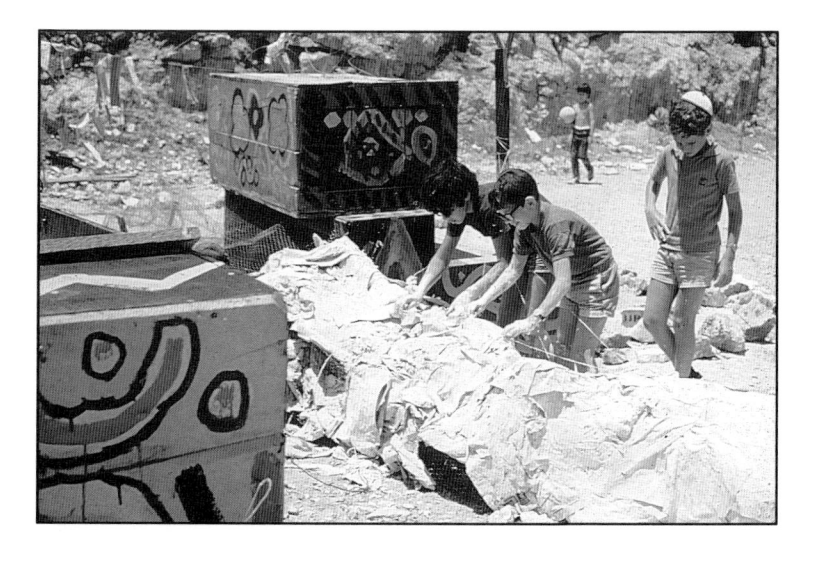

This section should be of interest to the multi-culturally aware teacher. As these illustrations attest, collaboration in art exists in many countries other than the U.S.

(top) Children at work on a sculptural project which combines— painted boxes and muslin dipped in plaster of Paris and draped over wire forms. Israel

(center) Styrofoam blocks are easily manipulated and accident free because of their weight.

(bottom) Children enliven a park by cutting out life-sized, painted figures and attaching them to benches. Israel.

(top) In an unusual way of studying art history, a docent at London's Tate Gallery leads children through a recreation of Marcel Duchamp's "Games."

(center) A team of New Zealand sixth graders pose before a large scale mask taken from Maori mythology.

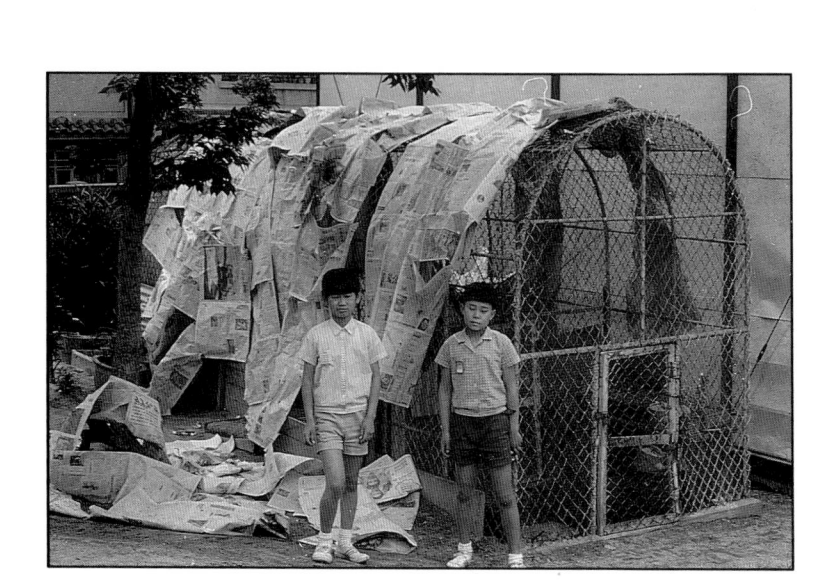

(bottom) In an elementary school in Japan, children engage in Christo-inspired wrapping activities. Other subjects were playground equipment and the school grounds—all of which were covered with paper. The teacher, as can be expected, was a close student of the American art scene.

A FINAL WORD

During the sixties my concern for collaborative group art was equaled only by my interest in what is currently know as Discipline Based Art Education. The gurus of the new youth sensibility sat at one end of a see-saw, and Jerome Bruner with his theories regarding the structure of knowledge and Manual Barkan with his desire to see art education extend beyond activity into the realms of criticism and history lay directly opposite. I spent far more time with Barkan for the simple reason that the doctoral dissertation I was writing dealt with the development of curriculum based upon art appreciation, an arcane but nevertheless term which called for a unified approach to studio activity, critical skills and history.

When people ask me how it is possible to serve two such apparently opposing ideological masters, the seemingly anti-intellectual process centered group art and the more reflective, discursive inquiry modes of criticism and history, I caution them not to confuse content with methodology. Group art can be messy, nonreflective, unpredictable and irrational, just as a discipline based curriculum can be deadeningly dull and have little relevance to student interests. In either case, we are talking more about bad teaching than questionable content. While I support the views of discipline based practitioners, I also believe that an awareness of how art can function within process centered social settings is also a necessary condition for a balanced art program. Historical and aesthetic questions can be raised in collaborative situations and one approach need not preclude the accommodation of the other. I am one of the greedy teachers who wants it all.

There is a story about the dancer Nijinsky, fresh from his triumphs in Moscow, arriving in Paris to work with the great theatrical impresario, Serge De Diaghalev. At their first meeting, Nijinsky asked, "What do you expect of me?" To which Diaghalev replied simply, "Astonish me."

Although the "astonishment" factor — the ability to amaze, to startle, to electrify—has always been in short supply in education, the ability to generate such states of mind has always resided in the best of our teachers. It is depressing to realize that so many educators will go through life without having known that sense of aesthetic exhilaration educators so readily abrogate to the artist. Periodic uses of collaborative action may be one way for us to reacquaint ourselves with what we sought when the world was young, when we sought the pleasures that awaited us in the realm of the unexpected.

"WHO GOES THERE?" (above)—This is an example of a teacher's attempt to attune students more closely to their immediate environment. Large sheets of newsprint were taped to public places such as school hallways, sidewalks, and parking lots. The marks left by shoes and tires were then developed more fully in the art room and assembled into an unusual mural. The teacher was William Allen of Brockton High School, Massachusetts.

THE HOUSE OF CARDS (page 50, top)—I placed a group of large squares of painted cardboard left over from a community event outside my office window. Since I lived across the street from my place of work, I knew all the children in the neighborhood. I asked them to spend some time each day re-arranging the squares in a new design. This lasted until the rains came and "melted" the cardboard. The principle of slotting was borrowed from designers Charles and Ray Eames' game, "House of Cards."

PICTORIAL MAPPING (page 50, center)—In a fourth grade in Kyoto, the class was divided into teams to "map" the school grounds. They were asked to locate their classroom in relation to the general layout of the school and to indicate through the use of drawings, trees, cars, and outbuildings to clarify the overall plan of the school, grounds, and neighborhood. At this stage, general relationships among spaces and structures were the focus of attention. Establishing accuracy of scale was dealt with in the second stop.

THEMATIC INSTALLATIONS (page 50, bottom)—We used to call them "environments," now they are "installations." The term in either case refers to large scale transformations based upon a theme or idea. In this case, a 4th grade has turned its classroom into a section of a jungle. An activity such as this touches many bases—art, social studies, art by individuals, and art by the group.

51

THE WORLD'S LONGEST DRAWING—Two fifth grade boys asked me if I would like to see the "world's longest drawing." When we unrolled it in the hallway at the central administrative offices, we discovered the work was over fifty feet long, revealing a story that was born in September and ended around Christmas. Since it was executed in a hard pencil on manila paper, the contrast between line and surface was too low to use for reproduction. I asked the artists to go over sections with felt pens to show points of change in drawing and content.

In their eagerness to please, they re-drew the full scroll and in so doing couldn't resist improving the work as they went along. On the second try, they continued to work on the early section at the same level at which they ended and in doing so, obscured the process of change. The combination of one student's imagination feeding off another in the context of a scroll of unlimited length demonstrated what can happen when a team works in an unusual situation. The physical act of unfurling paper freed the flow of ideas in a way not possible when working on a single sheet of paper.

LIVING THE PICTURE (above)—The "tableaux vivant" wherein paintings are recreated by members of a community is perhaps the earliest form of group art. These living reproductions give students an opportunity to work with light, painted backgrounds, and costumes while maintaining an intimate relationship with an art work. Traditionally associated with religious subjects, the idea of "staging" an art work would work equally well with any subject, from a Persian miniature to a Russian lacquer painting of a folk tale. The painting shown here is Bernardino Luini's "Adoration of the Magi" and was part of an annual Christmas program at a middle school.

THE SPONTANEOUS PUBLIC "PAINT-IN" (below)—Informal mural making for the entire community is popular in Europe and Mexico as well as the U.S. The public "paint-in" is an effective way of having parents work next to their children in an unusual setting. This photo was taken in a park in Amsterdam.

THE SPRING PARADE—High schools often sponsor parades for various occasions. In this example every art teacher received an announcement of the parade soliciting their participation. The teachers, in turn, discussed the event with their classes. Those who desired to participate, formed groups which met periodically to create their contributions which included decorating the family car, displays for trucks, and banners large enough to span a boulevard. Two favorites were a parade of dogs in various costumes and huge cereal boxes worn by a class of 5th graders. Selecting winners in various categories was part of the final ceremony. One teacher commented as follows:

"We celebrated no special occasion other than the joy of getting together and shaking up the town. The mayor joined us and there were even mounted police. Best of all, our parade invited participation from many schools, parents, assorted dogs, and anyone else who cared to join in. We turned cars into floats and little children into a strung out aggregation of waddling cereal boxes. Paper mache over chicken wire was also a popular form of construction and was used for prehistoric monsters as well as a dragon's head. The merry-making which climaxed the parade included eating, dancing, frisbees and a rock concert. It's our own way to herald the coming of spring in New England and an effective way to bring the community and its schools together."

THREE FROM JAPAN—*Teachers associate art education in Japan with sequential mastery of art media (water color, oil pastels, felt pens, pen, ink and paper) and the development of pictorial skills through observational drawing, and compositional awareness. There is another side to Japanese art education—one that has its origins in America's history of artistic innovation. These environments reflect a part of the art scene in the U.S. and were created in a children's art program sponsored by the Tokyo School of Art.* **Photos:** *In the fantasy setting "The Land of the Giants" scale is reversed and humans are the size of moles, mice and other tiny creatures. Children must first solve the problem of structure before assembling the subject. Jungle environments include both large and small animals, hanging vines, clusters of fruit, all set within a painted mural background. Rennaiscence painting—an entire room is used as an extension. The mural treatment is painted directly on the wall. Harushi Issuka, President of the School, also a teacher in the program.*

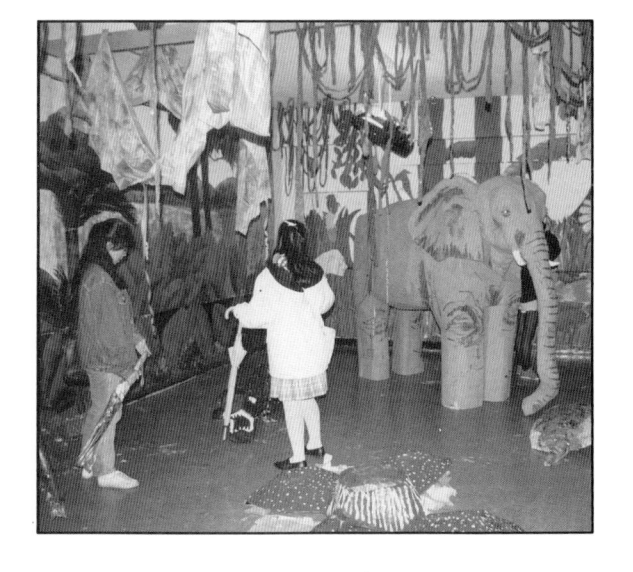

BIBLIOGRAPHY

Anderson, Y. (1991). *Make Your Own Animated Movies and Videotapes.* Boston: Little Brown & Co.

Battock, G. (1973). *New Ideas in Art Education.* New York: E.D. Dutton and Co., Inc.

Churchill, A. (1971). Working in and through the Group. In *Art for Pre-Adolescents,* (Chapter V, 107-142). New York: McGraw-Hill Book Co.

Crane, D. (1987). *The Transformation of the Avant Garde.* Chicago: University of Chicago Press.

Dover, D. (1984). *Learning in Groups.* New Hampshire: Croome Helms.

Hurwitz, A. (1968). Issues Relating to the Curriculum of Senior High Art Programs. *Art Education, 21 (4),* 16-19.

———. (1970). Turned-on Art. *American Education, March,* pp. 14-17

———. (1973). Moving the Art Program. *Art Teacher, Vol. 3 (3),* pp. 23-25.

———. (1973). *Experiment in Intermedia.* In G. Battock (Ed.), New Ideas in Art Education. New York: E.D. Dutton and Co., Inc.

———. (1976). School Art: The Search for an Avant Garde. In E. Eisner, (Ed.), *The Arts in Human Development.* Berkeley: McCutchan Publishing Corp.

———. (1975). Group Art: The Neglected Dimension. *Art Education, 28 (1),* 5-7.

———. (1976). "On Advanced Technology: Related Art Teaching at the Primary and Secondary Schools of Newton, MA., USA," *Leonardo Magazine, Vol. 10,* pp. 1-4.

———. "The Summer Arts Center As a Social-Aesthetic Laboratory," *Art Education:* National Art Education Association, Reston, VA, pp. 4-6

———. (1966). New Media in the Classroom and the Art Supervisor. *Art Education, 19 (4),* 20-21, 29.

Hurwitz, A. and Day, M. (1991). Newer Media: Ideas and Earthworks—Computers to Lasers. In *Children and Their Art,* (5th ed.), (Chapter IX). San Diego: Harcourt-Brace and Jovanovich.

———. (1991). The Social Dimension: Group and Instructional Games. In *Children and Their Art,* (5th ed.), (Chapter XV). San Diego: Harcourt-Brace and Jovanovich.

Jacques, D. (1984). *Learning in Groups,* New Hampshire: Dover.

Lanier, V. (1967). Have a Happening. Arts and Activities, pp. 21, 48-50.

Lidstone, J. and Bunch, C. (1975). *Working Big.* New York: Van Nostrand Reinhold Co.

London, P. (1992). *Step Outside: The Community as Visual Resource.* New Hampshire: Heineman Education Publications.

Mason, E. (1970). *Collaborative Learning,* London: Ward, Lock Educational.

McCabe, C. J. (1984). *Artistic Collaboration in the 20th Century.* Washington, D.C.: Smithsonian Institution Press.

Muller, G. (1972). *The New Avant-Garde.* New York: Praeger Publications.

Perr, H. (1988). *Making Art Together Step-by-Step.* Searcy, AZ: Resource Publications, Inc..

Shannon-Thornberry, M. (1982). *The Alternate Celebrations Catalogue.* New York: The Pilgrim Press.

Zollberg, V. L. (1990). *Constructing a Sociology of the Arts,* Cambridge: Cambridge University Press, 1990.

REFERENCES

[1]Natalie Cole, *The Arts in the Classroom*, John Day Co., N.Y., 1940 An earlier example is Hughes Mearns' classic statement of the Progressive era of education, Creative Power, Doubleday, 1929

[2] Seonid Robertson, *Rose Garden and Labyrinth*, Routlege and Kegan, 1963

[3]Marion Richardson, *Art and the Child*, U. of London Press, 1948

[4]Sybil Marshall, *An Experiment in Education*, Cambridge University Press, 1966

[5]Vincent Lanier ,*The World of Art Education According to Lanier*, National Art Education Association, 1991, p. 6

[6]Lowry Burges in Murray Road School, Newton, MA

[7]Udu Kulturman, *Art and Life*, Prager Publishing, N.Y. '71, p. 33

[8]Oliver Sacks, "A Neurologist's Notebook", New Yorker Magazine, July 27, 1992, p. 59

[9]John Cage "A Year From Monday" Middletown, Conn. 1967 p. 515

[10]Peter London - Unpublished M.S.

[11]Suzi Gablick, *The Reenchantment of Art*, Thames and Hudson, 500 Fifth Ave., N.Y. 1991, p. 168

[12]Jed Perl, *Gallery Going*, Harcourt Brace and Jovanovich, N.Y. '91, p. 208

[13]Gablik, Ibid, p. 181

[14]Susan Sontag, *McLuhan Hot and Cool*, American Library, 1967, p. 25

[15]Robert Slavin, "Cooperative Learning and the Cooperative School," Educational Leadership, Nov., '87

[16]William Ragan and C.B. Standler, *Modern Elementary Curriculum* New York: Holt, Rinehart and Winston, 1966) p. 192

[17]Ibid - Slavin

[18]Al Hurwitz and Michael Day, *Children and Their Art,* p. 314 5th Rev. Ed. Harcourt Brace and Jovanovich, 1991

[19]Diane Crane, *The Transformation of the Avant-Garde,* University of Chicago Press, Chicago, 1987, p. 62-63

[20]Arthur Efland, "School Art and its Social Origins", *Studies in Art Education, 26 (3)* p. 133-140

[21]Kathryn Bloom, *Innovation in Arts Education*, The NIU Art Museum, Northern Illinois University, 1992, p. 8

[22]Ibid, p. 140

[23]For a coherent review of events of this period, see Arthur Efland's *A History of Art Education*, Teachers' College, Columbia U., N.Y. 1990, pp. 237-258

[24]Ibid, p. 248

[25]Howard Conant, "Season of Decline", *New Ideas in Art Education* Gregory Battocock, Editor, E.P. Dutton & Co., Inc., 1963 p. 156

[26]Ibid, p. 158

[29]Francis Haskell, *Enemies of Modern Art*, New York Review of Books, June 30, 1983

[30]Gregoire Muller, *The New Avant-Garde*, Praeger Publishers, N.Y., 1972, p. 1

[31]Angiola R. Churchill, *Art for Preadolescents*, McGraw-Hill, 1970, p. 342. Churchill's understanding of what constitutes a happening is broader than Kaprow's. She describes it as "a combination of environmental sculpture and actors, audience, light, color, smell, music, dance, movement of bodies and objects, and sounds of every description. Through a general plan for action and dialogue may be sketched out in advance by the organizers...improvisation is the key....The happening also has much in common with the jam session, and with the ancient tribal dances that involved a high pitched freedom of expression for one and all." pp. 341-342

[32]Vincent Lanier, "Have a Happening," *Arts and Activites*, December 1967, pp. 21, 48-50

[33]*New Ideas in Art Education*, Gregory Battock, editor; Al Hurwitz, "Experiment in Intemedia", E.P. Dutton Co., Inc. 1973, p. 257

[34]Ibid, p. 260, 262

[35]Hurwitz, Albert (1972). *A Supervisor's Analysis of the Initiation of a Curriculum Development Project in Art Appreciation for the Sixth Grade*, Unpublished doctoral dissertation, Pennsylvania State University.

INDEX